MY PARROT'S DEAD — THA...

Buzby is a buzzard!

Biggles
flies
back to
front

WYATT EARP
RULES — O.K. CORAAL?

A MAN'S BEST

GO GAY —
ITS CHEAPER

eat the rich!

**If you disagree
with graffiti
sign a partition!**

FAST FOOD
MAKES YOU
SICK QUICK

NIRVANA
NEEDED

POPEYE
— TELL
OLIVE
TO GET
STUFFED

SUPPORT WOMEN'S LIB —

PATCH

FAMILY TE... BREEDS CONTEMPT

DON'T BLAME

Home
IS
where
you
hang
your

Women like
simple things
in life — men!

Killjoy was
here

GOD — HE'S
ONLY HUMAN!

EPEAL
IBITION

sterility is heriditary

DRINK WET CEMENT
AND GET STONED

FLYING
IS THE
SAFEST
WAY TO FLY

VENI
VIDI
VD

In our company
we live in Days of
Whine and Rises.

SAV
TRE
EAT
BEA

100,000 LEMMINGS
CAN'T BE WRONG

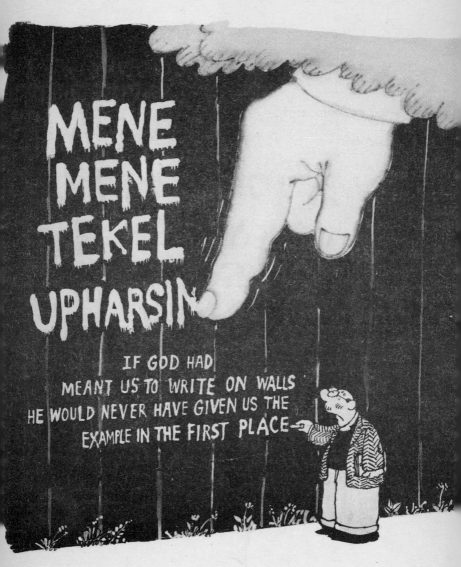

MENE
MENE
TEKEL
UPHARSIN

IF GOD HAD
MEANT US TO WRITE ON WALLS
HE WOULD NEVER HAVE GIVEN US THE
EXAMPLE IN THE FIRST PLACE—

THE GOLDEN GRAFFITI AWARDS

Collected and introduced by ROGER KILROY

Illustrated by

McLACHLAN

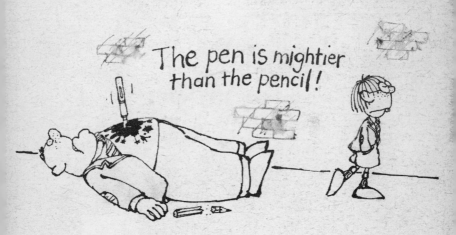

CORGI BOOKS

A DIVISION OF TRANSWORLD PUBLISHERS LTD

GRAFFITI 3: THE GOLDEN GRAFFITI AWARDS
A CORGI BOOK 0 552 11812 5

First publication in Great Britain
PRINTING HISTORY
Corgi edition published 1981
Corgi edition reprinted 1982
Corgi edition reprinted 1986

Copyright © Roger Kilroy 1981
Artwork copyright © Edward McLachlan 1981

Corgi Books are published by
Transworld Publishers Ltd.,
Century House, 61–63 Uxbridge Road,
Ealing, London W5 5SA

**Made and printed in Great Britain by the Guernsey Press Co. Ltd., Guernsey,
Channel Islands.**

CONTENTS

WELCOME!

Following the outrageous success of our first two Graffiti master-pieces—*The Scrawl of the Wild* and *The Walls of the World* (Corgi, 1979 and 1980)—McLachlan and I have been invited to present you with our nominations for the very first Golden Graffiti Awards, representing quite simply the very best of the graffiti of our times.

We have scoured* the land for the freshest and fruitiest and funniest graffiti and brought it all together in these pages for you and for posterity**. In our view all the graffiti here is worthy of an award and if you have any nominations of your own for future awards do let us know. While we'd love to inspect the actual wall on which the graffiti appears the cost of postage has become prohibitive so that rather than sending it to us brick by brick, a postcard will do. If we like your graffiti we'll send you a gold-plated aerosol can with enough spray for you to paint the town red. The address to write to is:

Roger Kilroy,
Golden Graffiti Awards
Corgi Books
Century House
61–63 Uxbridge Road
London W5.

* When I say scour, I don't mean *scour*! Our job is to record the graffiti—not remove it.
** If you don't like dirty words like this, turn to page 84 and really upset yourself.

Life is a tragedy— we're here today and tomorrow.

The Most Profound Graffiti Award:

Graffiti writers are philosophers. They contemplate the human condition. They realise that a slight inclination of the cranium is as adequate as a spasmodic movement of one optic to an equine quadruped utterly devoid of any visionary capacity and consequently use the visual loud-hailer of the blank wall to communicate to the rest of humanity their own understanding of life in all its aspects.

If you didn't understand a word of that, read on . . . (If you did, you've bought the wrong book.)

TWO CAN LIVE AS CHEAPLY AS ONE — FOR HALF AS LONG

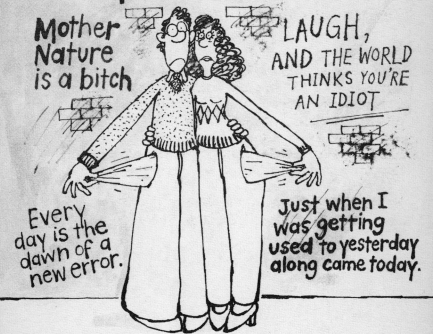

Mother Nature is a bitch

LAUGH, AND THE WORLD THINKS YOU'RE AN IDIOT

Every day is the dawn of a new error.

Just when I was getting used to yesterday along came today.

LIVING ON EARTH IS EXPENSIVE
But it does include a free trip
around the sun!

A friend in need is a bloody pest!

THE THIRTIES ARE HERE AGAIN
Join the Surbiton
Hunger March -
THIS
WE

Give a man
enough hope
and he'll go
and hang
himself

HAPPINESS
CAN'T BUY
MONEY

11

REALITY
IS AN
ILLUSION

Cupid's aim
is straight
but he still
makes a lot
of Mrs.

HE WHO FINDS
FAULT IN HIS
FRIENDS HAS
FAULTY FRIENDS

Don't get mad
– get even!!

Laugh, and the world laughs with you
– SNORE, AND YOU SLEEP ALONE !!

Where there's a will – there's a greedy solicitor getting in on the act.

HOW COME IT'S NEVER THE COLD GIRL WHO GETS THE FUR COAT?

ALL THAT GLITTERS IS NOT GOLD
All that doesn't glitter isn't either

SHOPLIFTERS HAVE
THE GIFT OF THE GRAB!

Just because
I not speak English,
don't mean I deaf.

I get on
with everyone
— except humans
and Tories!!

WHAT
DID WE DO
BEFORE
NOSTALGIA?

SMILE — THINGS
MAY GET WORSE
MORE SLOWLY

GOD
BLESS
ATHEISM!

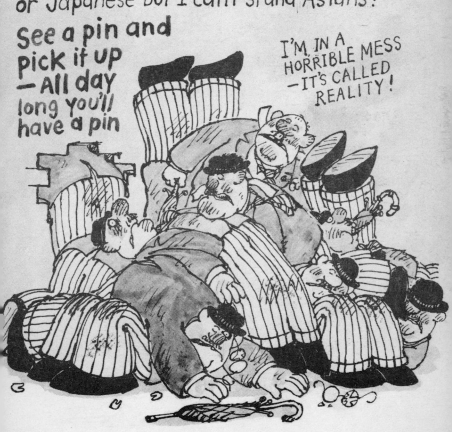

Tomorrow is just another day

MONEY IS THE ROOT OF ALL EVIL - AND A MAN NEEDS ROOTS!

We've been having a bad spell of wether

HE WHO PLOUGHS A STRAIGHT FURROW IS IN A RUT.

I'M HAPPY!!

Don't worry, you'll soon get over it

NOW IS THE WINTER
OF OUR DISCOTHEQUE

NOTHING IS
EVER AS EASY
AS IT LOOKS

I've just been to my
mother-in-law's funeral
—I wanted to make sure she was dead!

IGNORE
THE TRUTH
BELIEVE
IN
FANTASY

Beware of the doc.

The Healthiest Hospital Graffiti Award:

In hospital Doctors and Nurses scribble graffiti on charts at the ends of beds to take their minds off each other and to help preserve their patients. As you'll see from what follows, graffiti doesn't need an Arts Council grant while it has the National Health Service.

When you're healthy
you walk tall.
- When you've piles
you sit tall

OPERATING
THEATRE

The blood
will run & run
- Marvellous show!

I'M SCHIZOPHRENIC
That makes four of us!

Is having hysterics
a kind of sick joke?

'M HAVING
ROUBLE WITH
MY BREATHING
Get something
to stop it!

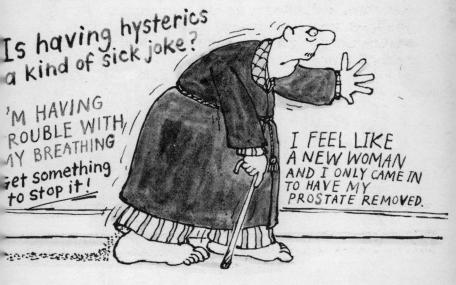

I FEEL LIKE
A NEW WOMAN
AND I ONLY CAME IN
TO HAVE MY
PROSTATE REMOVED.

Gynaecologists put in a hard day at the orifice.

I NEED HELP IN BEING ABLE TO ADMIT I NEED HELP.

You need Help!!

I'D RATHER HAVE A FULL BOTTLE IN FRONT OF ME THAN A FULL FRONTAL LOBOTOMY!

IS ARTIFICIAL INSEMINATION THE INNOCULATE CONCEPTION?

I could live a better life if I had a better body.

IF YOU'D LIVED A BETTER LIFE YOU MIGHT HAVE HAD A BETTER BODY!

HELP! I'M A PAUPER!
Congratulations. Boy or girl?

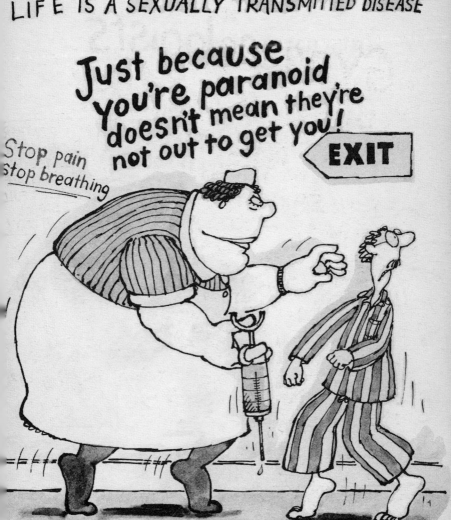

DEATH IS HERIDITARY

O.K. I'M CURED OF SCHIZOPHRENIA
BUT WHERE WILL I BE
WHEN I NEED ME?

No Nurse!
I said 'Remove his
spectacles and
prick his boil!'

I don't mind the pain
- it proves I'm alive!

Constipation is the thief of time
DIARRHOEA WAITS FOR NO MAN

Avoid life - it'll kill you
in the end

THE WAY DOCS INJECT THEIR FLOCKS
SMALL WONDER THEIR PATIENTS FEAR 'EM.
THE CURE PRODUCES BURNS AND SHOCKS;
THEY DON'T JUST PRICK, THEY SERUM.

Am I still alive?

Trying to relax is a great strain on my nerves

ACCEPT ME FOR
WHAT I AM —SICK !

It'll never
heal if
you picket.

I USED TO BE A WEREWOLF
—BUT I'M ALL RIGHT NOWWWWWWWH.

I've got too much blood in my alcohol stream.

Is there an imaginary cure for hypochondria?

HIC!

WASH YOUR NECK -I'M A VAMPIRE

VASECTOMY MEANS NOT HAVING TO SAY YOU'RE SORRY.

Go gay - It means not having a vasectomy

HYPOCHONDRIA KILLS - O.K? Eventually

HOW DO YOU TELL THE SEX OF A CHROMOSOME? Take down its genes!

Let the local C.I.D. stitch you up.

Matron must be an astronomer — She asked to see Uranus

Abandon hope — you'll feel much better!

I hope I don't die before they find a cure....

My surgeon must hate me
—he keeps sticking the knife in.

RICKETS, LOVELY RICKETS
—IT WAS AT LOUDRES WHERE
I SAW THEM.

Uncle Alf died of asbestiosis
—It took six months to cremate him!

OPERATIONS ARE
FUNNY—THEY HAVE
YOU IN STITCHES.

SLEEPING
PILLS ARE
NOD ADDICTIVE

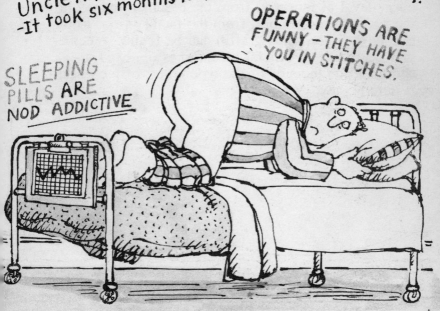

To err is human – to totally muck things up needs a computer.

The Least Oafish Office Graffiti Award:

Wherever you work, the graffitist works too. At every level of industry, from the basement garage to the roof-top boardroom, from the factory floor to the executive toilet, great graffiti can be found. Whether it is posing as an official memo or is tippexed in shorthand on the side of the typewriter, office graffiti is here to stay.

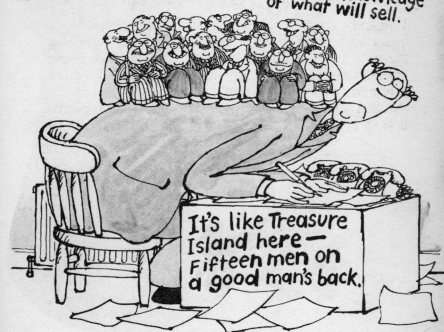

Being employed here is like making love to a hedgehog — one prick against thousands!

INCOMES POLICY HERE IS ABOUT AS SIGNIFICANT AS A BLUSH ON A DEAD MAN'S CHEEK

Always put the important before the merely urgent!

God has mercifully withheld from man the fore-knowledge of what will sell.

It's like Treasure Island here — Fifteen men on a good man's back.

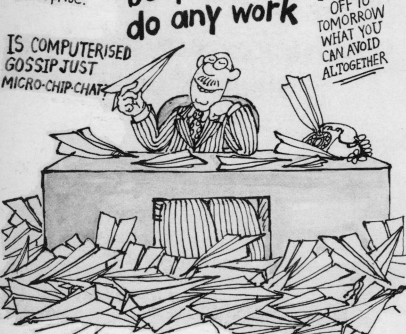

WHEN IN DOUBT — MUMBLE.

ALWAYS BE SINCERE — EVEN WHEN YOU DON'T MEAN IT

Work is the lowest hierarchal level in any human enterprise.

I'm much too busy here to do any work

NEVER PUT OFF TO TOMORROW WHAT YOU CAN AVOID ALTOGETHER

IS COMPUTERISED GOSSIP JUST MICRO-CHIP-CHAT?

WHEN IN TROUBLE — DELEGATE

THE ROAD TO SUCCESS IS USUALLY UNDER CONSTRUCTION

Things are not nearly as bad as they seem.
NO, THEY'RE A BLOODY SIGHT WORSE!!

WHAT HAS THE BOSS GOT THAT I HAVEN'T
How did he get it?

The union is my shepherd; I shall not work

LORD GIVE ME PATIENCE
BUT HURRY!
She's my favourite typist too!

The work is hard
The pay is small.
So take your time
And sod 'em all.

Doing a good job here is like
wetting your pants in a dark suit;
You get a warm feeling but nobody notices.

**EMPLOYEES ASK FOR A SALARY
INCREASE AT THEIR OWN RISK**

THE MONEY
THAT MEN
MAKE
LIVES
AFTER
THEM.

Where there's
a will there's
an inheritance
tax!

Everyone has
a right to my
own opinion.

THE LAW OF INCREASING IMPORTANCE

AN EXECUTIVE'S IMPORTANCE IS PROPORTIONAL TO THE
DISTANCE FROM HIS OFFICE DOOR TO THE DESK IN FEET,
MULTIPLIED BY THE THICKNESS OF HIS OFFICE CARPET
IN CENTIMETRES.

THE KISS-OF-DEATH LAW

THE LIKELIHOOD OF WHAT APPEARS TO BE A WISE AND
IMPRESSIVE STATEMENT OF FACT BEING REVERSED BY
NATURE ALMOST IMMEDIATELY IT IS MADE, IS ENHANCED
BY THE IMPORTANCE OF THE SPEAKER.

GLORIA, I LOVE YOU,
I WANT YOU, I WOULD
DIE FOR YOU, GO THROUGH
FIRE FOR YOU, CLIMB MOUNTAINS
FOR YOU, SWIM OCEANS FOR YOU.

See you Saturday
—If it isn't raining /G.

When all
else fails, scream!

DON'T PANIC
—COUNT TO TEN
Then panic!!

Help the police— beat yourself up.

The Very Important Poster Graffiti Award:

All around us are billboards, hoardings and posters featuring advertisements and announcements of every kind. Sometimes they inform us, sometimes they infuriate us, very rarely do they entertain us—that is, unless the graffitist has been around. Take a look at the choice signs of the times...

Are good coppers born, or made?
OR HATCHED IN JAM JARS?

Write to: ▒▒▒▒▒▒▒▒▒▒▒
▒▒▒▒▒▒▒▒▒
▒▒▒▒▒▒▒

A POLICE CAREER

Nothing acts faster than Anadin
I'LL TAKE NOTHING THEN

Say it with flowers
Hit her over the head with a bouquet!

KEEP BRITAIN TIDY!
POST YOUR RUBBISH TO FRANCE

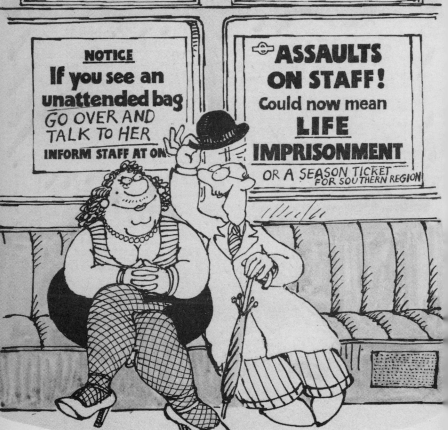

Don't let anxiety kill you
— Allow the Church to help.

A phone call costs less than you think

SOON IT'LL COST MORE THAN YOU BELIEVE!

BUZBY

Make someone happy.
STUFF BUZBY FOR XMAS?

H

THE HARBOROUGH PLAYERS
PRESENT

HAMLET
son of Piglet

BY
WILLIAM SHAKESPEARE

STARTING JUNE 6TH-30TH
TICKETS AVAILABLE AT OFFICES

SEATS £1-£1 50 — SHOW-7.30

walls have ears
— so be careful what you say
especially about their sausages!

← **This way to the creche**
— THERE'S BEEN AN ACCIDENT IN KENSINGTON

The Annual Conference of Clairvoyants has been cancelled due to unforeseen circumstances.

The DUBLIN SAMARITANS are ex-directory.

LAST TUESDAY'S MEETING OF THE APATHY SOCIETY HAS BEEN CANCELLED —

— So what?

THE SCOTS SUPPLY THE POETRY
THE IRISH SUPPLY THE PROSE
THE WELSH SUPPLY THE MUSIC
THE ENGLISH SUPPLY THE AUDIENCE

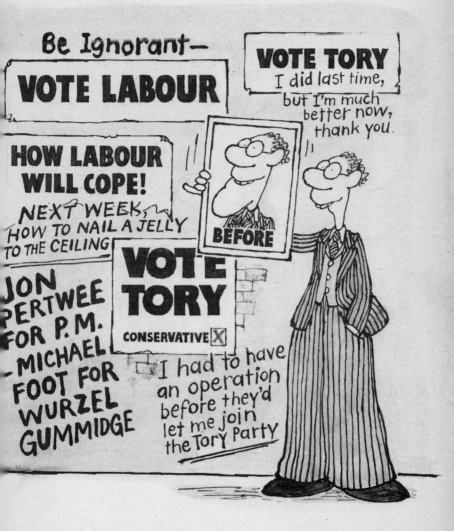

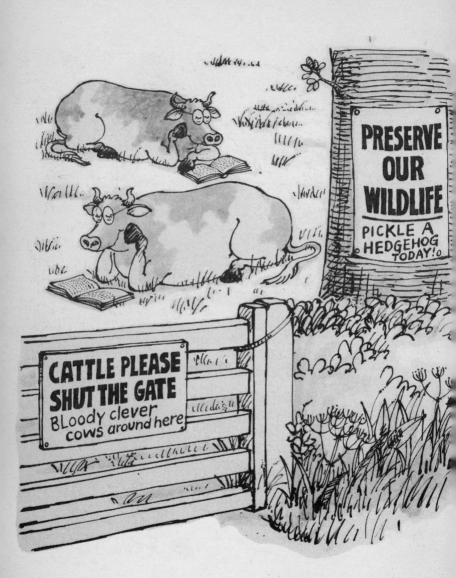

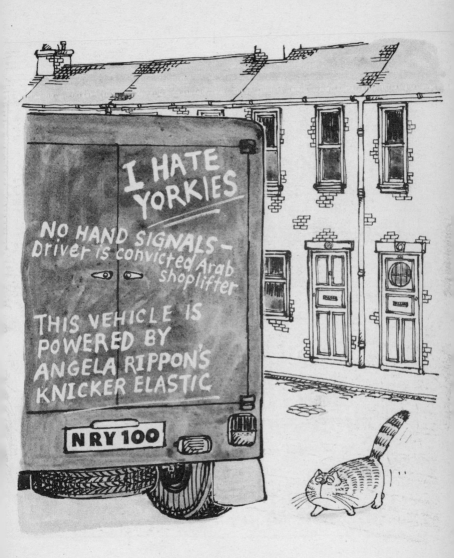

Join the Army
and see the ^NEXT world.

The Army will make you a man!

Will it make me one
— six foot tall
with a hairy chest
— Emma Bulstrode
(Miss)

The Army

Drop in on your local SAS office – before they drop in on you!

COULD YOU LEAD A 30 MAN COMMANDO RAID ON AN ENEMY BEACH AT NIGHT

Ask for information at local office

ROYAL MARINES OFFICERS

Join the professionals

AND LEARN TO KILL WHILE BEING PAID FOR IT!!

REMEMBER CLACTON SEAFRON SUMMER OF 1978!
— EAST END BOOT BOY.

It's a man's life in the British Arm
— but an Afghan's life in the Russian Army!

SAVE ENERGY!
BE CREMATED WITH A FRIEND!
Stand in the dole queue <u>quietly</u>.
Make love slowly!

Be apathetic today
— I THINK I'LL LEAVE IT
UNTIL TOMORROW.

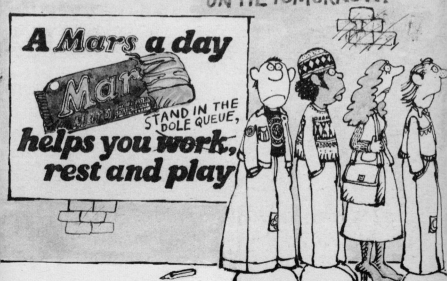

Corporal punishment smacks of sadism.

The Wurst Un-Akaddemic Graffiti Award:

Schools, colleges and universities have long been responsible for some of the most imaginative and illuminating of all wall-wisdom. Of course graffitists are getting younger all the time and it won't be long before a playpen isn't a wooden cage for toddlers but a writing implement for pre-teen scribes.

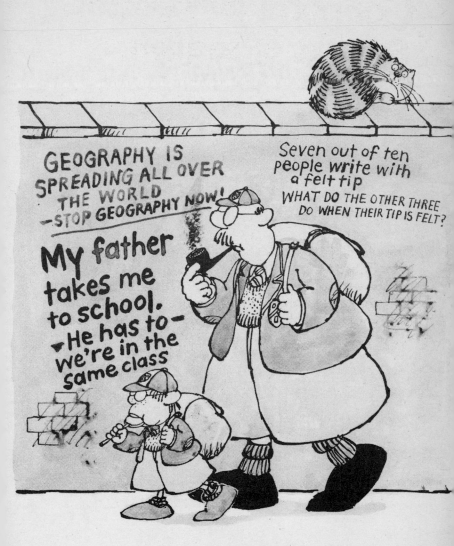

THIS GOVERNMENT ARE MAGIC — WATCH THEM DISAPPEAR AT THE NEXT ELECTION!

There may be a lot of Singhs but a thousand million Chinese can't be Wong!

Shakespeare got the idea for Hamlet from Bacon.

I MAY NOT be VERY CLEVER but at LeAST I'M GOOD to LOOK at!

This radiator is turned off in sympathy with the rest of the class.

ROSES ARE RED
VIOLETS ARE BLUE
YOU'RE BLOODY NOSEY
IF YOU READ THIS
ALL THROUGH

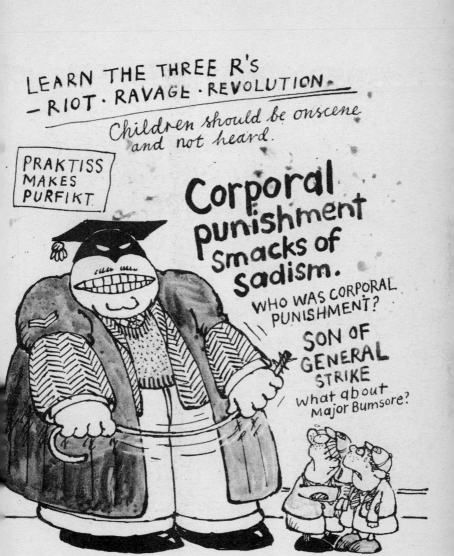

LEARN THE THREE R'S
— RIOT · RAVAGE · REVOLUTION

Children should be onscene and not heard.

PRAKTISS MAKES PURFIKT

Corporal punishment Smacks of Sadism.

WHO WAS CORPORAL PUNISHMENT?

SON OF GENERAL STRIKE

What about Major Bumsore?

God is black
YES, SHE IS !!

Little Women
become Very Big Women
— You should see my Mum!

ISAAC NEWTON WAS RIGHT
— THIS IS THE CENTRE OF GRAVITY.

TOILETS

Katy did it
for kicks

Go to
university
— Be the most
qualified
in the dole queue

Examinations
— Nature's Laxative

90% OF HEADMASTERS TAKE "THE GUARDIAN"
—THE OTHER 10% BUY IT!

WHERE'S THE BLOODY CHALK THEN?

Forty Years On
—and this bloody
place might have
fallen down
by then.

SCHOOL DINNERS
ARE GOING UP AGAIN
—THEY'RE VERY
HARD TO KEEP
DOWN!

BIGGLES FLIES OPEN

I LEARNED TO PLAY THE TRUMPET AT 84 must have been hell for those living at 82 and 86.

HAVE YOU READ THE PENGUIN BOOK OF QUOTATIONS? I never realised penguins had that much to say

KEEP LONDON TIDY — EAT A PIGEON

Noah's Ark is bigger than Joan's.

The Popular Personality Graffiti Award:

You may meet the Queen, you may appear on *Desert Island Discs* and *This Is Your Life*, you may be given the Freedom of the City of London and a seat in the House of Lords, but you haven't really arrived until you've been scrawled on a wall. Immortality is when your friends tell you you're a brick—and it's true!

Princess Anne for Mare

SHAKESPEARE WAS A TRANSVESTITE
It's true, duckie.
A. Hathaway (MR)

I think I'm done now.
Mrs Beeton

DESCARTES THOUGHT HE WAS HERE

Ronald Reagan doesn't dye his hair — He's just prematurely orange!

RICHARD the ZIONHEAR was the first King of ISRAEL

Yorick is a numbskull!

DAILY NEWS

MORE RUSSIAN SETBACKS IN AFGHANISTAN

If this is world domination, you can stuff it private Ivanov

Vandyke was a lesbian truck driver

LORD LUCAN IS ALIVE AND WELL AND LIVING IN SLOUGH

He can't be well then

MARY WHITEHOUSE IS AN ANGEL
She bloody well ought to be!

MAGGIE THATCHER SHOULD GO INTO POLITICS

Annie Walker for queen

NOAH'S ARK WAS BIGGER THAN JOAN'S
But Joan's was maid of orleans

I'm off my head
charles I

Isn't it great to have Reagan as President
- A real actor after all these clowns

AND I'M A KING CHARLES SPANIEL

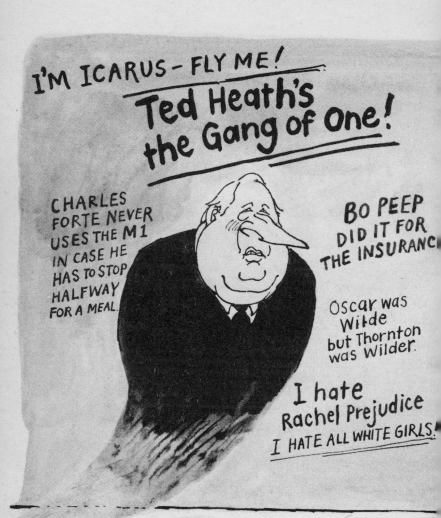

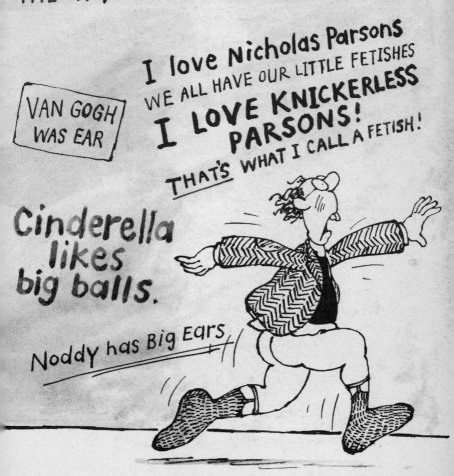

I love Nicholas Parsons

WE ALL HAVE OUR LITTLE FETISHES

VAN GOGH WAS EAR

I LOVE KNICKERLESS PARSONS!

THAT'S WHAT I CALL A FETISH!

Cinderella likes big balls.

Noddy has Big Ears

WHY DID THE AVON LADY SMILE?
— BECAUSE MAX FACTOR.

MARY POPPINS
IS A JUNKIE.

ANDY PANDY
IS A POOFTER
— HE LIKES
TEDDY BARE !

I'm not an
infant prodigy
— I just have very
stupid parents

HELL HATH NO FURY
LIKE A PRIME MINISTER SCORNED
— M. Thatcher

I wouldn't bet on that!
signed 3 million unemployed

CAN ALISTAIR COOKE?
DID EZRA POUND?
DOES SAUL BELLOW?

Shirley Bassey
Sings
– 0000.K Big Spender

Adam was
rejected for
Eden the apple.

Magnus Pyke
reaches parts
David Bellamy cannot reach.

Destry Rides
Again – Why?

BERNARD MANNING HAS
PARTS IN PLACES WHERE OTHER
PEOPLE HAVEN'T EVEN GOT PLACES.

Thought for food.

The Most Edifying Restaurant Graffiti Award:

Eating establishments throughout the world have long been a valuable sauce/source of graffiti. While waiting to be served, we impatient diners put pencil to napkins or write with soup on the tablecloth. And of course we only have to wait so long because the staff are so busy scribbling on the walls in the kitchen . . .

MY WAITER IS HOMOSEXUAL
—Tray Gay!

We're only open to tell you we're closed

THIS RESTAURANT HAS THE BEST TARTS IN SOHO — Thanks, dearie

I love children
BOILED OR FRIED?

Goblin your food is bad for your elf.

CAN YOU HELP ME OUT?

Which way did you come in?

I've just been to McDonalds
— They're still getting revenge for
the Massacre of Glencoe!

A Restaurant after my
own heart — CESAR BORGIA

Watch out for the
hidden extras at
this restaurant:—
botulism
salmonella
gastro-enteritis

THE WAITER HAS
SHAKY HANDS
—I'VE GOT SOUP
IN MY FLY!

THE LUNCHPACK
OF NOTRE DAME
EATS HERE
— HE'S A SANDWICH MAN!

EAT PRUNES AND FIGS — THE WORLD WILL FALL OUT OF YOUR BOTTOM

There are no cockroaches here — THE RATS HAVE EATEN THEM AL

You've seen the show: NOW eat the pies — Sweeney Todd

The water in this establishment has been personally passed by the manager

The prices in this restaurant merely keep pace with inflation. — IN ARGENTINA

GENTLEMEN

A miss is as good as a male.

The Best Ladies Graffiti Award:

Queen Victoria would not have believed it, but women do do it—and in the Ladies too! In fact some of the female graffiti that follows was actually found in the women's convenience at Victoria Station. Whatever else they are, the Graffiti Awards are not sexist. We firmly believe in women's writes . . .

I've got one thing
in common with my husband
—We married on the same day!

I'VE GOT TWO THINGS IN
COMMON WITH MINE
—HE DOESN'T LIKE ME,
AND I HATE HIM!

Love is blind
—and when you
get married you
get your eyesight back

Support
Women's Lib
—use his razor.

I
HATE
YOUR LOUSY
GUTS YOU DIRTY
DRUNKEN FOULFACED
LOUDMOUTHED SWEATY
OLD POX DOCTOR'S CLERK!

WOMEN WERE BORN
WITHOUT A SENSE OF
HUMOUR SO THAT THEY
COULD LOVE MEN AND
NOT LAUGH AT THEM.

69

ALL'S FEAR IN LOVE AND WAR.

A penny saved is ridiculous

The bigger they are the harder they maul.

UNDERNEATH EVERY SUCCESSFUL MAN THERE IS A WOMAN

RUTH IS STRANGER THAN FICTION

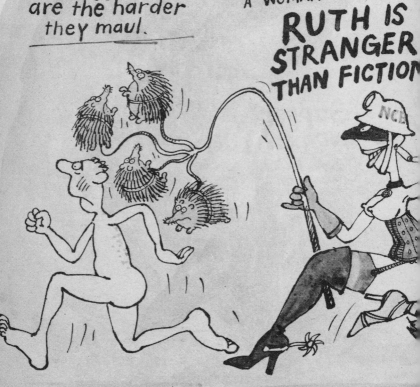

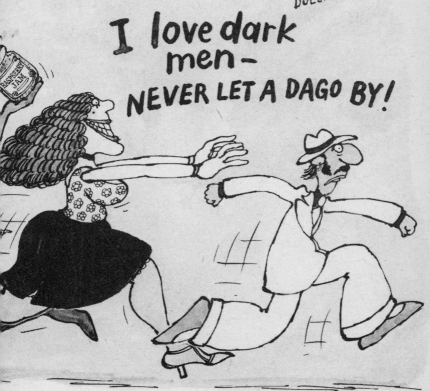

Where there's a pill, there's a way.

TRANSVESTITES FOOL — O.K.?

Be chairy. — or you'll find you're sitting on a pouffe!

When God made man she was only testing.

DO YOU LIKE MASKED BALLS? No, I like to know who I'm sleeping with.

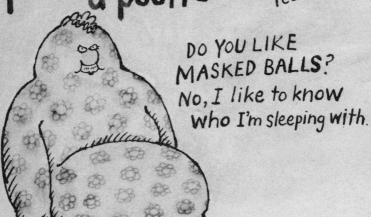

LAY OFF THE PILL
AND LET NATURE
TAKE ITS CURSE

I can speak
12 languages
—and can't say
no in any of them!

I'M A LESBIAN
How are things
in Beirut then?

Beneath
a rough
exterior
often beats
a harlot
of gold

IF YOU CAN'T
SAY IT TO
HIS FACE,
SAY IT BEHIND
HIS BACK.

CHASTE
MAKES
WASTE

GET THE
ABBEY HABIT
—sleep with a monk

Women over 40 needn't worry about the menopause.
— WORRY ABOUT THE MEN WHO DON'T!

DO MEN CALL US BIRDS BECAUSE WE PICK UP WORMS

BEHIND EVERY GREAT WOMAN THERE'S A MAN WHO TRIED TO STOP HER

I LIKE IT AND HIM — IN THAT ORDER!

A seven day honeymoon makes one weak.

Has anyone got a contradictive pill?

You're ignorant!

Yes, six months!!

AN
ORGASM
IS A
GLAND FINALE!

I've lost my virginity
HAVE YOU STILL GOT THE RECEIPT?

It's the cow that gives the milk – so why does the bull get all the credit?

IT'S HARD TO BE GOOD
It has to be hard to be good!

A man must do something to relieve the monogamy.

The Best Gents Graffiti Award:

There once was a fellow named Rafferty
Who went to a gentleman's laffertry.
 When he saw the sight
 He said 'Newton was right,
This must be the centre of grafferty.'

This can be no doubt about it—the cradle of graffiti
is the Gents . . .

JULIAN SUCKS ORANGES

I am perfectly well adjusted - Do not fiddle with my knob.

I'm gay and Irish - I go out with girls.

Nowadays Bachelors must insert their masculinity

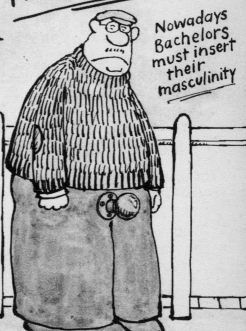

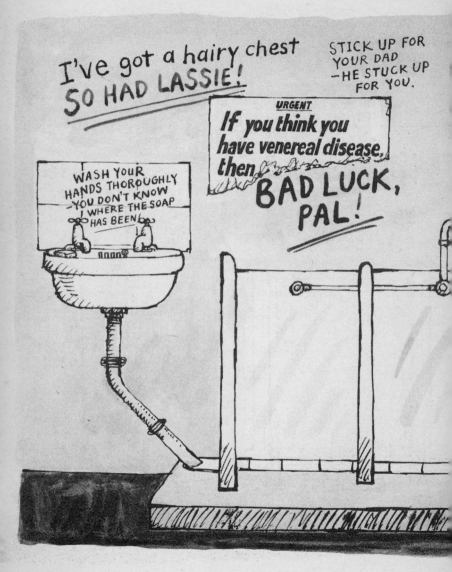

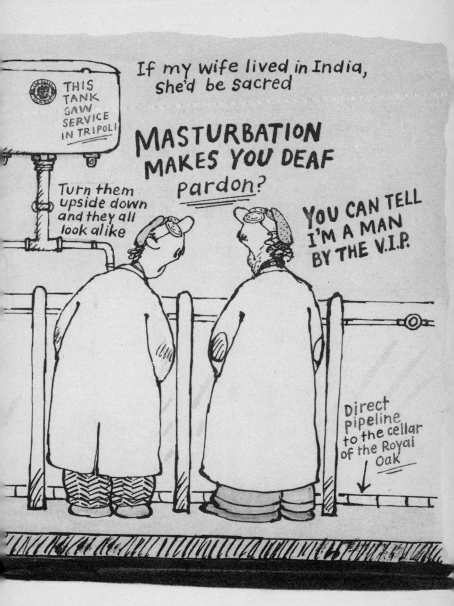

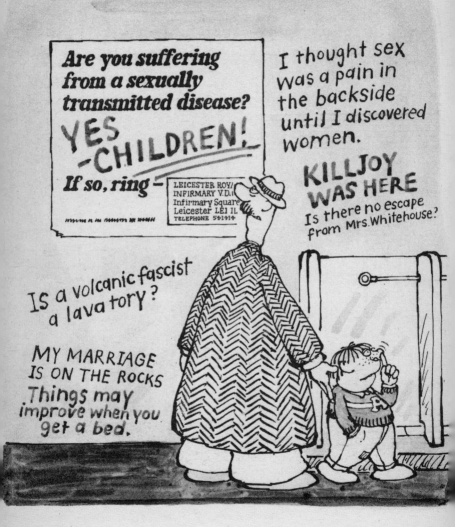

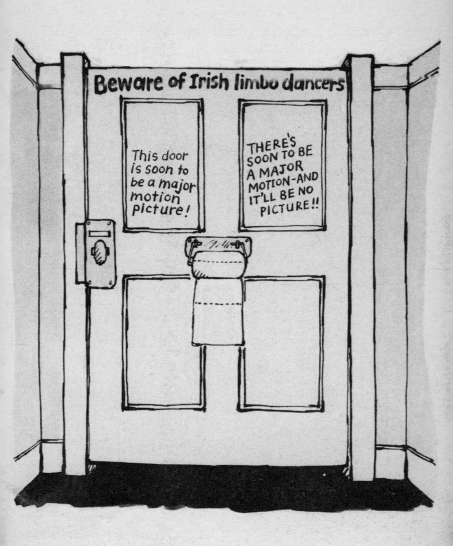

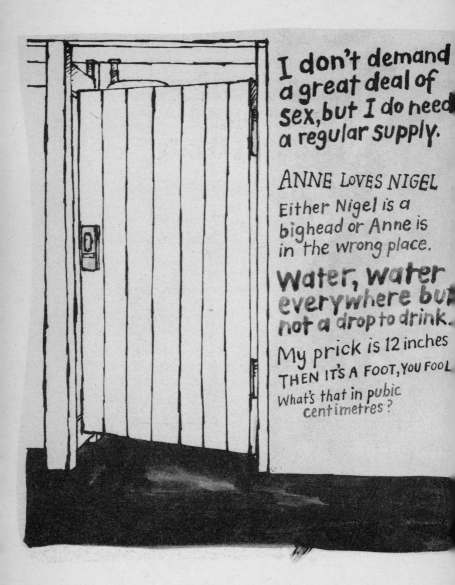

I don't demand a great deal of sex, but I do need a regular supply.

ANNE LOVES NIGEL
Either Nigel is a bighead or Anne is in the wrong place.

Water, water everywhere but not a drop to drink.

My prick is 12 inches
THEN IT'S A FOOT, YOU FOOL
What's that in pubic centimetres?

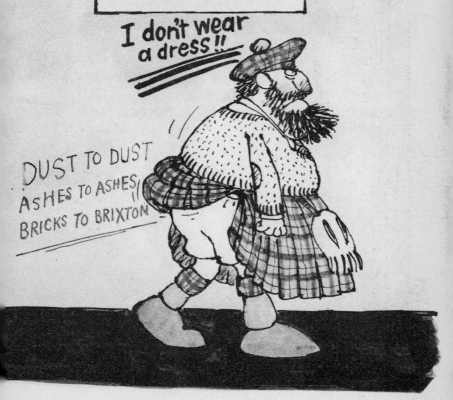

All the world loves a four-letter word.

The Naughtiest Graffiti Award:

From now on things can only get worse. If you are squeamish, of a nervous disposition, believe in censorship, and always undress in the dark—this sexion is not for you.

FAMILIARITY BREEDS

MY girl's got a 39·37 inch bust I'D LOVE TO METRE!

The Devil finds work for idle glands

TIS BETTER TO HAVE LOVED AND LUST, THAN NEVER TO HAVE LUST AT ALL.

Don't be half safe — Be cocksure

TWO'S COMPANY, THREE'S AN ORGY

It takes two to tangle

WHO WANTS A PRETTY BOY THEN!?!

A swinging family that really rates is Mr and Mrs and Master Bates.

Why do prostitutes keep parrots?
I GUESS THEY CAN ALWAYS DO WITH A COCKATOO

If at first you don't succeed try a little ardour.

I hate prostitutes!
AND I HATE SUBSTITUTES!

One in the bush is better than two in the hand

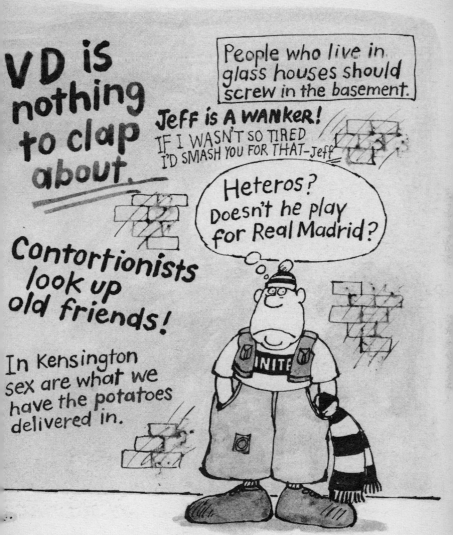

VIRGINITY IS
LIKE A BALLOON
—ONE PRICK AND IT'S GONE!

ORAL SEX
IS TOPS

Anal sex
is
bottoms

Sado-masochism means
not having to say you're sorry

A message
to all virgins
—Thanks for
nothing!

Sex is
good for two

CUNNILINGUS IS A REAL
TONGUE-TWISTER

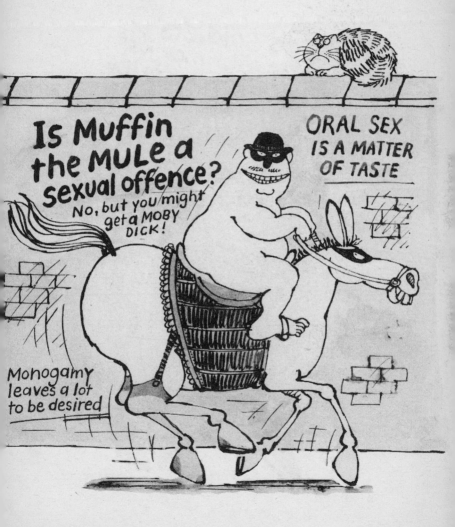

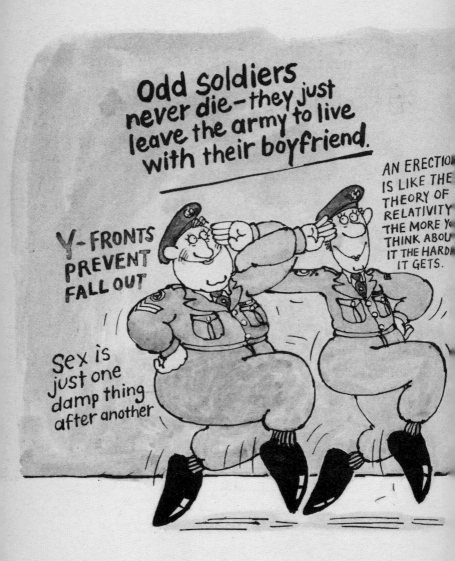

I SEE MY GIRL REGULARLY—
BUT THERE'S NO HARD FEELINGS

Bestiality is going to the dogs!

ONLY RIGHT ONES DRINK MARTINI !

VAT 69 ISN'T A DRINK
—IT'S A TOPSY-TURVY TAX

Yorkies are made in York— good job they weren't made in Goole!

SEX IS ALL-EMBRACING

Please think again, Veronica.
I find it hard to accept 'sod off' for
an answer to my proposal. .

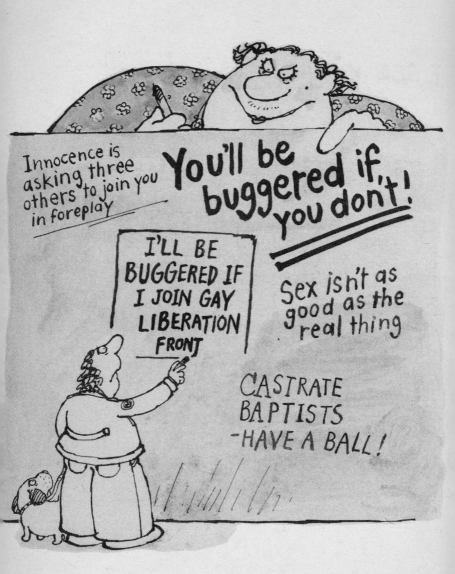

I'm so unlucky.
I even get caught
writing graf

MY PARROT'S DEAD — THAT'S LIFE

Life is just a bowl of toenails.

Buzby is a buztard!

WYATT EARP RULES — O.K. CORAAL?

GO GAY — ITS CHEAPER

giggles
flies
back to
front

A MAN'S BEST FRIEND IS HIS PR...

eat merick? PROCRASTINATE NOW!

FAST FOOD MAKES YOU ...CK QUICK!

POPEYE
...ELL
LIVE
...GET
...UFFED!

SUPP...
MAKE HIM SLEEP ON THE WET PATCH

He who laughs last doesn't get the joke!

NIRVANA NEEDED

FAMILY...BREED...

DON'T BLAME

BEDE THRIL

Killjoy was here

Women like the simple things
...the simple things
...in life — men!

GOD — HE'S ONLY HUMAN!

DRINK WET CEMENT AND GET STONED

PAGE 96

Sterility is heriditary

VENI
VIDI
VD

...YING
...THE
...FEST
...Y TO F...

In our company
we live in Days of
Whine and Rises.

100,000 LEMMINGS CAN'T BE WRONG

SAVE TREES
EAT A
BEAVER